The Rain-Maiden
and the Bear-Man

THE INDIA LIST

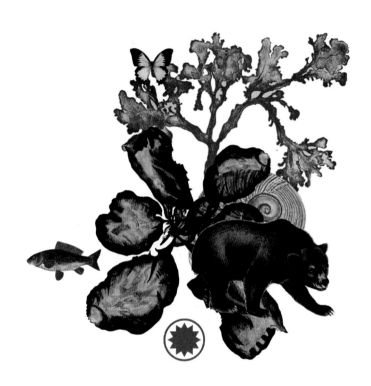

EASTERINE KIRE

The Rain-Maiden and the Bear-Man

CALCUTTA LONDON NEW YORK

Seagull Books, 2021

Text © Easterine Kire, 2021
Digital collages © Sunandini Banerjee, 2021
This compilation © Seagull Books, 2021

ISBN 978 0 8574 2 618 5

British Library Cataloguing-in-Publication Data
A catalogue record for this book is available from the British Library

Typeset and designed by Sunandini Banerjee, Seagull Books
Printed and bound by Hyam Enterprises, New Delhi, India

CONTENTS

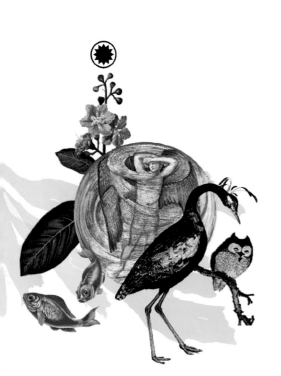

The
Rain-Maiden
and the
Bear-Man

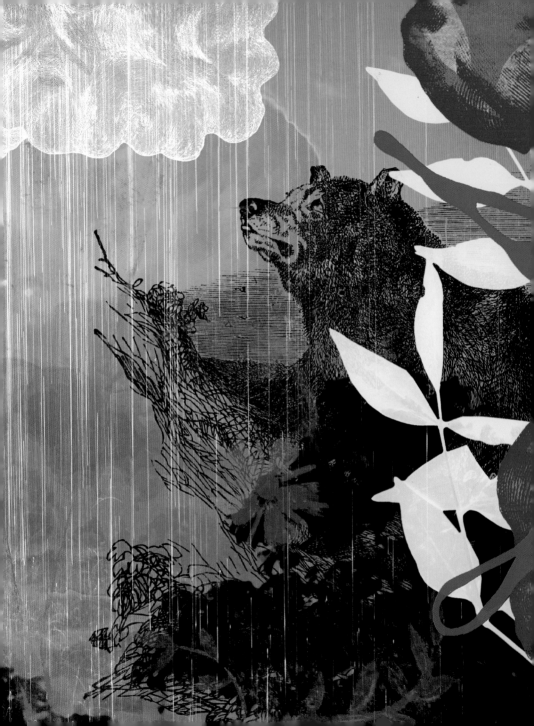

There were very few to whom the Rain-Maiden showed herself. The fortunate ones who glimpsed her were blinded by a vision of infinite loveliness, diamond raindrops in a shower of sunlight, furiously falling raindrops leaving faint maiden shapes in the air. She was deeply loved by the Bear-Man. Son of a man who set out hunting but then did not return for two years, who had wandered into the woods and there been turned into a bear. When he came back to ravage the maize fields, his clansmen shot him dead. Bear-Man was half-man, half-bear—not a man in a bear's body, as his father had been. One half of him well understood the world of men. The other was all bear, attacking humans if they ever stepped into his hunting grounds. This same half didn't mind the bees swarming after him, stinging him all over as he fled from their hive, paws and whiskers smeared with golden honey.

Bear-Man could be gentle with those who were gentle, and aggressive with those who appeared a threat. One morning, crawling down to the stream, he saw that another was there before him. This annoyed him. The other animals knew this part of the stream was his and made sure to bathe at a spot well away.

He had never encountered an intruder before and so he paused for a moment, wondering what to do. As he stood there thinking, the intruder turned. And she was so incredibly beautiful that Bear-Man's irritation at once gave way to awe. Her hair hung low to her waist. When she moved, Bear-Man thought she must have washed her hair in his stream because it shone so wet and silky. But when he looked again he saw that her hair was made of rain! Moving with a light grace, she came up to him and said, 'I'm sorry if I have kept you waiting, Bear-Man.'

'How do you know my name?' he asked, incredulous, 'And who are you?'

'Everyone in the forest knows your name. And I have seen you often. I am Rain-Maiden. My father is Rain. In raintimes, we have seen you resting in the hollow of the oak tree, sometimes fast asleep.'

Bear-Man thought she was the most beautiful creature he had ever seen. And he fell in love with her at once. But when she moved and he could see himself—a lumbering, fur-covered being, ungainly and fearsome—reflected in her hair, he thought: How can someone like her ever love someone like me? And the fear made him angry. 'Go away,' he said gruffly, 'find your own stream—don't waste my time.' Rain-Maiden was taken aback, yet she spoke gently: 'I know you are better than this. You are a kind creature, especially to those smaller and weaker than you. I know you don't mean what you're saying.'

Bear-Man was shaken by how well she seemed to know him. And wished he could tell her how he really felt. But if she scorned him, or, worse, if she laughed at his looks, he would not be able to endure it. Better not to risk it, he thought, I don't mind my friends and neighbours making fun of me, but if *she* were to tell me how ugly I am, I'd want to die. So, he stamped his foot and said, 'No, I like being on my own. I don't want to be kind or friendly—not today, not tomorrow, not ever. And the sooner you learn that, the better!'

Rain-Maiden was hurt by his words. Bear-man could see that and felt awful but he'd already said too much. He was afraid she might say cruel things to him too, if he said he was sorry now. So he thrust out his chest and stood as tall as his eight-foot frame would allow him, and roared, 'Do you hear?' so loudly that the leaves on the trees fluttered and some even fell to the ground.

Rain-Maiden ran away as fast as her feet could carry her. Bear-man thought he heard a sob as she went past, and what looked like raindrops splashing on either side of her as she ran. 'Could I have made a mistake?' he thought for a moment. As she disappeared from sight, he felt alone and empty. He tried to convince himself that he'd done the right thing. But his heart was not at ease. 'She thought I was kind—no one has ever said that to me. People think I'm a troublemaker. They're always trying to shoot me. Small boys throw stones at me with their slingshots. The flesh wound from the hunter's gun last summer still troubles me. No, people don't think I'm kind at all. And the other animals? Why, if they saw me going soft, they'd be all over me. The little dormouse would never leave my tree stump and cadge food off me for ever. They keep their distance

because they think I'm big and bad. If word got around that I am kind, I'll never have a moment's peace again.'

Thus Bear-Man struggled with his true self and the image he had built up over the years for his own protection. And the struggle grew and grew. He could not sleep. And everything seemed to have changed. Honey now tasted bitter. He began to lose weight. One morning, he'd wake up and shout 'I'm not kind, I'm the meanest bear in these parts!' The next morning, he'd whimper, 'But I am kind. I like being kind.' This went on and on as he fought to bring back the real self he had kept hidden for so long.

In the meantime, Rain-Maiden wept a day and two days more and a half-day more. Then she left the forest. And never returned. When raintime came again, Bear-Man sat on his tree stump and waited. But Rain-Maiden was not to be seen. Sometimes his heart leapt when he saw the rain fall so fast and furious it looked like her hair. But when it cleared, he saw it was a rain-drenched tree, no more.

Even now, he lives in that forest, afraid to step out of his bear-skin and become his true self.

And every raintime he still looks at the rain and wishes Rain-Maiden would return.

Forest Song

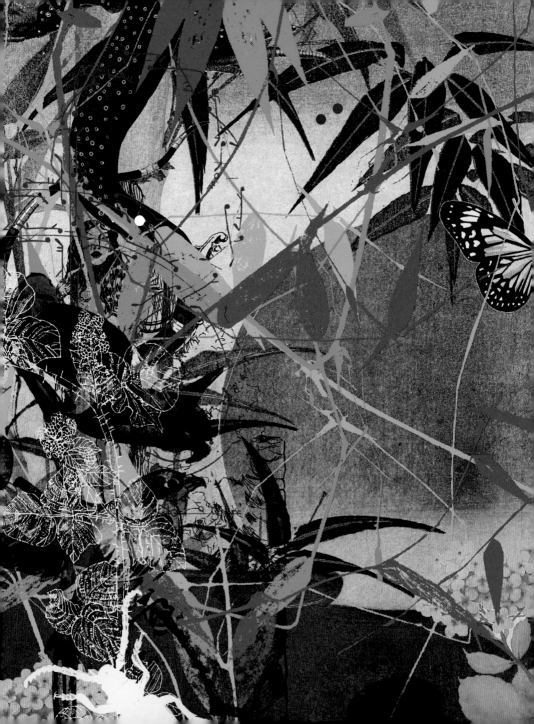

The elders call it *forest song,* that inexplicable phenomenon of people going missing from the village, only to be found three or four days later, or, like Nito, ten days later. By then, it's too late—they are never the same again. Those who are retraced remember nothing. Except an incredibly sweet music coming from the forest, sweeter than the songs of courtship their age-mates sing at the harvest festival when marriages are contracted and the feast of the harvest combines with the feast of the marriage. The songs draw them into the forest, deeper and deeper into the heart of the dark woods, until they grow so loud that the singing seems to be inside their heads, sung up close into their ears, their harmonies swaying back and forth and sending them into a deep slumber.

Bilie's sister was seven when she heard about it. A young man had been missing for two days. In the early morning, the crier sounded the call to the menfolk. *Forest song,* murmured her mother to her father.

'What did you say, Mother?' asked Bilie.

'Hush, Zeno, nothing that concerns you.' Zeno knew what that meant. Older folk said that when they thought you might be scared by something,

something happening in the village or outside it. She did have some idea what it might be. She and her sister had overheard some women talking about it when they were out in the woods, not too far from the village. Then they had run back home, fearful yet unable to speak to their mother about what they'd heard.

In the afternoon, when she and her friend were on their own, Bano asked, 'Do you know what really happened to Bise's mother?'

'No, tell.'

'Sure you won't run off and tell your mother?'

'I'm biting my finger, see?'

'All right then, but come closer—I can't shout.'

Zeno drew closer. 'She listened to a *forest song*,' said the older girl conspiratorially.

'She sat in the forest and listened to a song—for five days?'

'Oh, you're hopeless,' Bano said, exasperated, 'It doesn't happen like that.'

'Oh please, please,' Zeno begged, 'I'll give you my wrist-band if you tell me.' The two girls moved deeper into the house. It was very dark in the inner room after being out in the sun for so long.

'You're sure no one's home?' Bano asked.

'Yes,' Zeno responded, 'they're all in the fields. I had to stay and dry the paddy.'

'All right, then,' Bano said softly. She was older than Zeno by a year and a head taller. Her mother had died when she was three. She had grown up in her grandmother's house, listening to the old woman's stories until

she too died a year ago. Her father was always out hunting, and the eight-year-old girl was left pretty much on her own. She was old enough to stay back in the village while the others went to work in the fields. But not big enough or strong enough to help with the crops yet. She sometimes looked after her cousin who was three, and too big for his mother to carry to work.

Zeno took out her wrist-band from a niche in the wall and passed it to Bano without a word. The other girl took it and slowly tied the red threads together. The little woven band looked pretty on her brown wrist.

'Now tell me,' Zeno demanded, because she had bought her right to the story. The girls settled down by the hearth. Poking at the ash with a twig, Bano began.

'When you hear a forest song, you should cover your ears and run. It's the song of the forest spirits. If you stop to listen, they draw you into the woods and then keep you there for days and days, feeding you roots and worms.'

'Is that why Bise's mother was gone so long?'

'I'm not so sure about her. Some people say she had a lover.'

'What?!'

'Hush, not so loud. You forgot that Vide eavesdrops all the time?' Vide was the village clown.

'But what are you saying, Bano? That Bise's mother had gone to be with a lover? Didn't everybody say she'd been taken by the forest spirits?'

'Oh, that's what her husband said when he got her back. But didn't you notice her face was black and blue? That she couldn't get out of bed for three weeks because two of her ribs were broken? Have you ever heard of spirits beating up people?'

Zeno was quiet. She wasn't sure she wanted to hear this about Bise's mother who was a kind woman and always gave her treats when she visited. Her husband, on the other hand, scared her. He would look absently at her, sometimes leer at her, and, though she was young, she sensed that was not the way grown men were supposed to look at little girls. Her stomach would knot in fear whenever he looked at her like that. She tried not to go to their house too often.

But her mother would chide her if she refused to run errands to Bise's house. 'Her father scares me,' she'd tried to explain. Her mother had refused to listen. 'That's ridiculous. Pulie's harmless, he just isn't a jolly sort of man.' So Zeno gave up. But whenever she had to go to Bise's house, she made her way there very quietly so as not to attract his attention. Once he'd crept up behind her. Gripped her hard and laughed and felt her crotch while she struggled to get free. He reeked of tobacco and the sickly sweet smell of rice-brew. Zeno ran home, gagging all the way. She was white with fear when she reached home but she couldn't bring herself to tell her mother what had happened.

She just couldn't believe what Bano was saying about Bise's mother. It made Zeno uncomfortable to talk about the things that grown-ups did. She felt a little dirty about it. But Bano was dying to tell her more. She changed the subject. 'You said you'd tell me more about the *forest song*.'

'So I did,' Bano replied, now bored. 'Really, Zeno, you are such a simpleton at times. Don't you know that the *forest song* is what we heard when we were at your grandmother's field last year?'

'Yes? That sweet melody that some girl sang all day from across the river?'

'That was no girl.'

'What was it then?'

'A spirit of the forest. Sometimes they sing in groups, like an age group coming home from the fields and courting on the way. That is how people who lag behind are trapped by them. They think they're their age-mates and go to join them and are spirited away by them. Then the whole village has to look for them—because they can never come back on their own.'

'Why not?'

'Oh, why're you such a baby? Because the spirits want to make new spirits out of them. The humans have to struggle to get them back. The men have to go out in pairs, so one can stop the other if he should become enchanted. Don't you see, how the men stick bitter wormwood behind their ears when they set off? Spirits can't abide bitter wormwood. I've often seen your mother throw bits of it into your basket when we go off to the woods.'

'She does. I can't remember ever going out without a bit of bitter wormwood.'

'Well, if you didn't have that, you'd have been taken off by a forest song long ago. You're so silly, Zeno.'

Zeno put up with the remonstration because she wanted to listen to more of what the older girl had to say. But Bano was opening the door to leave.

'I have to fetch water before Father comes home,' she said as she ran off. Oh well, some other time then, Zeno consoled herself, watching her friend sprint across the village square.

'Zeno, get up!' Her mother shook her awake. It was dark outside and Zeno struggled to shake the sleep from her limbs.

'Hurry!' her mother said again, 'you have to take Father's food to him.' Zeno slid to the floor and ran to the water-pots and splashed her face with cold water.

'But what about you, Mother?' she asked. 'Didn't you say last night that we would both go?'

'I can't, Zeno, the baby's due today.' Zeno felt a bit frightened when she heard that. When her sister, younger by three years, was born, she had been too young to think anything of it. Now her mother, pregnant for what seemed like the whole year, was ready to give birth again.

'Shouldn't I stay with you then?' she asked, concerned though she hoped her mother would say no. Childbirth frightened her. Bano had told her terrible things about it. She wanted no part of it. But if her mother asked her to stay, she would stay and do the best she could.

After a long pause, her mother said, 'No, I don't need you. The baby's got another hour or so—time enough to call your aunt. Your father needs you more. Now, get dressed and get started. It will be early afternoon by the time you reach. Mind, you don't take that silly Bano with you. That girl gads about all day. She's more of a nuisance than a help.' Zeno kept quiet. This was not the first time her mother had voiced her disapproval of Bano. In any case, she had no intention of taking Bano with her. It was too far to walk to the clan forest where her father was cutting wood. Bano would be needed at home to babysit her cousin and they couldn't possibly take the little boy along with them. He was a hefty child, and impossible to carry for long distances.

Her basket packed with freshly cooked food and a gourdful of rice brew, Zeno set out for the forest. It was dark still and she had to peer at the

path to make sure she did not step on bits of wood or sharp stones. She was not used to the new shoes her father had bought her from his last trip to Kohima. So she continued to walk to the fields and the forest in her bare feet, calloused by habit. Her father didn't like it at all. But she was hoping he wouldn't notice.

Her father had been gone two days now. He preferred to sleep in the little hut they had built in the forest, because it helped him save time and thus cut more wood. Most of the men worked in this manner, sleeping overnight in the forest and working singly or in pairs. By this afternoon, her father's rations would have dwindled considerably. But he planned to finish cutting and stacking wood that day. So he had asked his wife to send some food.

Zeno walked as surely as a grown woman because she had made this trip so often with her mother. Ahead lay the bamboo grove. In the half-dark, the bamboos made her heart jump a little, swaying and creaking in the wind. She ran past them as she remembered the story about a man being found dead there in her grandfather's day, tiny spirit-spears thrust all over his body.

Her heart pounding, she looked back once—but there was nothing there. She calmed herself a little and walked on at a slower pace. Later she would run again if she needed to. It was strange that no one was about. The villagers were hard-working and liked to set out early for their fields. Maybe they had taken the other path. That would explain why it was so silent this morning. But after a few moments, she heard the loud clang of a machete against a tree followed by a man's swearing. Instinctively, she stepped off the path. There was a large hollowed-out tree stump ahead. Noiselessly she made her way to it and climbed inside. No one could tell she was there.

Clutching her basket, she sat there silently, waiting for the man to pass. If he were from her village, she would come out of hiding. But the man was still standing on the footpath, rolling tobacco in cigarette paper. As the match flared to life, Zeno gasped and then held her hand over her mouth—it was Bise's father. Of all the men in the village, he was the one who should not find her alone on this dark forest path. She dared not even think of what he would do to her. Terrified, she crouched lower into the hollow and prayed he would walk past soon.

But Bise's father sat beneath the tree for a long time, smoking his tobacco and cursing when it went out. 'Damn this damp tobacco!' he said before lighting it again and dragging on it deeply. Would he never leave? Zeno was impatient to get to her father and give him news of her mother. It was not until another twenty minutes had passed that he finally got up to go. Zeno crawled out of her uncomfortable hideaway, shook the dirt off of her clothing, slipped her basket back on and began to sprint along the path.

But Bise's father was a hunter—his ears cocked at the faintest sound, and he shouted, 'Who's there?' Zeno flew into the forest, pricking her feet on thorns but not caring. Bise's father began to give chase. Zeno zig-zagged further into the forest. Somewhere up ahead was a little brook and a short path to a field. She could run there and seek the company of other people. Only then would she be safe from him. But her terror had thrown off her sense of direction. She realized she had sped too far past the path. But she couldn't stop running now. Even if she was late with her father's food, she had to run as far as possible from this man. If he caught her, she knew he would do something terrible to her. She ran on and on. Further into the forest, perhaps there would be another field path, so many people cut

across the forest to get to their fields, perhaps she would come to another path soon, Zeno's thoughts raced through her mind as she kept running. Panting, she ran northward now, making for the places where the forest cover was thicker. She dared not look behind her to see if he was still chasing her. She couldn't afford to close the distance between them.

Suddenly, she saw a flicker of movement in the woods ahead. An old woman leaning over to line her basket with firewood. '*Atsa, Atsa!*' she called in the customary greeting used by youngsters for older women. The woman was startled at the sight of the breathless Zeno.

'What is it, my child? Why are you running as though from the devil?'

'Oh, *Atsa*, he mustn't catch me.'

'Who, my child? There's no one here but you and me.'

'It's Bise's father, he'll soon be here. *Atsa*, he's an evil man, don't let him take me.'

'There, there, my child, no one dare come near you when I am here. You are safe with me.' Zeno collapsed near the woman's stack of wood, overwhelmed with relief, with the thought that she was safe now. If he saw her with the old woman, he would slink away, not because he could not overpower both of them but because he would not dare risk the village people coming to know about how he behaved with the women he was traditionally bound to protect.

Twelve days later, Zeno's father and his clansmen were about to abandon their search for the lost girl. Her mother was inconsolable. The baby's occasional cries reminded the village that there was new life in that house. Otherwise, it was as though a death had taken place. The women who

visited Zeno's mother had no words to comfort her with. They sat together in the dark inner room, their tears running together in unspoken loss.

'My child, my child,' her mother wailed as she touched her daughter's clothing, or her little dolls made out of maize shells, their long pale and brown hair falling in neat plaits.

'Have you named the child yet?' a neighbour asked, trying to distract her.

'Yes. His grandmother's named him Viebilie. We call him Bilie.'

'What an odd name. What does it mean?'

'It was on the fifth day of Zeno's disappearance that she named him. She says the name has two meanings: *The-one-who-will-be-ours* or *The-one-we-claim-as-ours*.'

'Have you ever thought that Zeno's name could have been misinterpreted? If you use her full name, Zevino, it means, *The-one-who-is-good-to-be-with*. But Zeno means *Take-her* or *The-one-who-can-be-taken*. The old ones always say that names have power over our destinies?'

Zeno's mother sat silently, nursing her son. Then, she smeared her finger with spit and touched it to his forehead. 'He is mine—hear me, Spirits. I have staked my claim.'

The
New Road

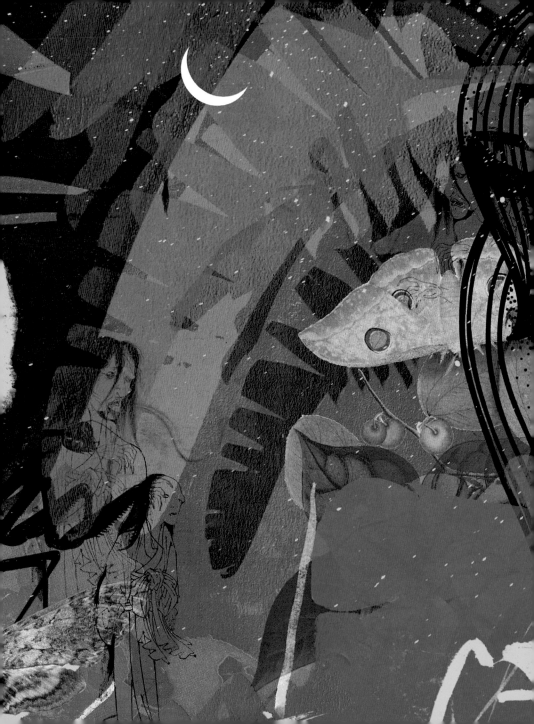

'Don't let your brothers come home by the new road, Nino,' her mother-in-law begged in the morning. Very late the night before, her brother and a kinsman had come to their house, too drunk to walk the rest of the way home. Her mother-in-law was visiting them for the weekend. She was a quiet woman, not the interfering sort at all. So, Nino was alarmed with this request.

'Why, Mother?' she asked, 'Why not the new road? It's shorter and wider. And when they are so drunk, they are surely safer on that road?'

'It is not a good road, Nino.'

'Why not, Mother? Is it a spirit thing?'

'Yes. But don't ask me more.'

'But they'll want to know why. They won't listen if I tell them not to go that way.'

'All right then, I'll tell you but, mind, you don't let the children know.'

'The first night they came home late, I was so troubled I could not sleep at all. Spirits of the road had followed them home, and they troubled me all night. You remember I left a little before dawn? Some of the spirits even had wings. Those were the most troublesome. As I lay in bed, I could feel their wings, light as a moth's, soft and fuzzy, brushing against my face. I kept waking up and swatting them away, but they just wouldn't leave.

'The men must have drunk a great deal because the spirits were drunk too—and not as harmless as the spirits of the road usually are. The ones that followed them home last night are malicious and mean. A new breed of spirits, home-grown. Didn't you hear them knock over the water pitcher? Did you think that was the cat? In my village, a man ran into them and they beat him so badly that his nose bled, his mouth bled, and in the morning, they found him dead by the village gate. We couldn't bury him in the village, because that sort of death is abominable and such people need to be buried far away.

'Last night I heard the spirits talking, they're vicious and vile. I kept very quiet. When your brother's friend opened the door to answer the call of nature, they finally left the house.

'You don't know that people in the village never open their doors after nine at night? You live in the town, you've forgotten the ways of the village. But the spirits never forget, they are the same in village and town. If you are late going home, they follow you, and, when the door is opened, they enter the house with you. And then plague you all night. Haven't you been startled awake by a pot falling to the floor? That was the work of spirits.

But when you go to the kitchen, you find there's nothing there. Nothing has fallen to the floor, and you wonder what it was.

'At other times they wake you, but you feel too lazy to get up and see. You think maybe it's the cat, and you turn over and go to sleep again, only to hear another clang from the kitchen. You wonder if it's morning yet, and you look out the window—but it's night still. That is what happens, Nino, if you open your door late. The spirits follow you in.

'The most dangerous are the river spirits. I wonder if they brought one home last night. Through my sleepy eyes, I thought I saw a beautiful woman in the room. She was so beautiful—I cannot find the words to describe her. And as I gazed at her, I felt a cold breath on my cheek, and my eyes snapped wide open. The air in the room was moist, as though someone had splashed river water about. And I smelt the river-mud smell of the river spirits long after the cold had gone. You must warn them not to come by the new road again.'

Nino knew the old woman was not lying because she was a strange soul, Paul's mother. People said of her that she has the gift, that she could see spirits and even communicate with them.

That night she heard her brother's voice hissing her name. It was very late, much later than the previous night. She pulled her quilt over her head and refused to go to the door. 'Nino, open the door,' he hissed, knocking softly again and again. Nino struggled to stay still. The spirits stayed for a few minutes, hissing and knocking. She could hear them talking too. 'Guess she's sleeping too deeply tonight,' said one voice. 'Let's go to Akru's then,' said the other. She heard the heavy shuffling of feet on her porch and her heart turned over, but she couldn't risk the children

being harmed. Let it go, she thought to herself, tomorrow when they've slept off their drunkenness, I'll tell them. Then she turned over and lay awake all night, listening for sounds that never came.

River and Earth

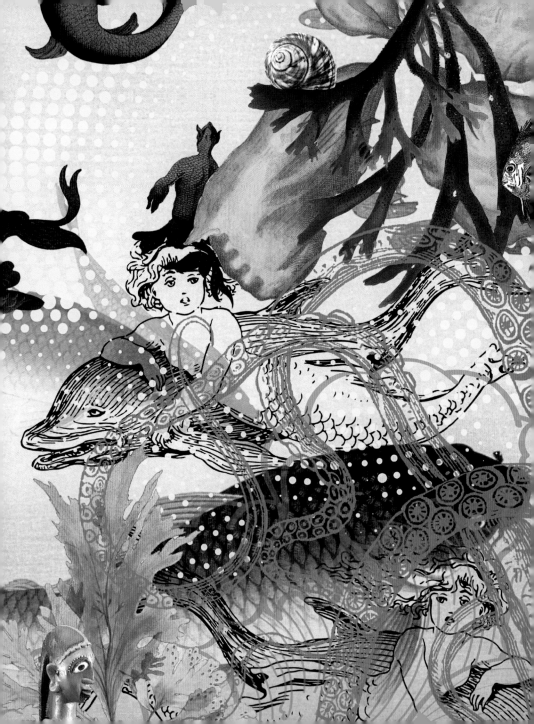

Josephus was young, smart, even handsome. He was doing well at his job at the bank and made the village proud. Another son in the big city of Lagos, another feather in the cap of Umuofia. That's what everyone said of him.

I think he met the *mammy-wota* at one of the office parties where everyone was trying to be sociable, especially with the big bosses. She was standing on her own, nursing a drink. Josephus saw her out of the corner of his eye, and then all he could think of was adjectives to describe her incredible beauty. Nothing felt worthy. He forgot all about the conversation he was having with his boss, the man in charge of his next promotion. Mumbling something about the heat, he excused himself and crossed the room. He could never remember who followed whom home.

Over the next few months, Josephus was the talk of the office and town.

'He's either doing very well or embezzling.'

'Did you see the car he's driving?'

'And the girl, huh? Wasn't she a looker?'

'I hear he's planning to buy a house.'

'How's he doing it?'

Back and forth went the talk as Josephus withdrew more and more from his friends. These days he rarely attended wedding receptions, birthday parties nor the numerous cocktail parties.

After five months, the talk turned.

'You know, I've noticed, he doesn't look good at all.'

'Yes, he's lost weight. And his eyes, have you seen his eyes? Like he hasn't slept in days.'

Of course, this kind of talk was bound to reach the elders sooner or later. 'Didn't someone say he has a lady companion who's very fair? A *mammy-wota*! That's what she is! A *mammy-wota* and the poor boy doesn't know he's wasting away!'

The elders got together and paid him a visit. After many knocks, Josephus finally opened the door. Bleary-eyed and weary, he stood there, mumbling something about too much work, apologizing that he couldn't entertain his clansmen. One elder pushed him aside and held the door open for the others.

'Is this the way we've taught you to welcome your clansmen? Shame on you, son, we haven't come all this way to be told you are too busy to meet us.'

They all trooped in and sat down, and were astonished at the luxury on display. But they couldn't get much out of him. After a futile two hours, they got up to leave.

Outside, one elder said to the rest: 'I saw her, it was for a moment of course, a *mammy-wota* never allows you to look at her for long. I was standing near the door, admiring a painting, when I saw a movement out of the corner of my eye. I froze, and then she passed by the door.'

'What did she look like?'

'Well, like any other *mammy-wota*, so beautiful that words fail to describe her beauty. *Mammy-wota*, mother of the river, she'll give young Joseph great wealth, she already has, no doubt. But she'll take her reward. No man who marries a *mammy-wota* dies old. They like them young.'

In another week, Josephus was found dead from undetermined causes. The police broke down his door when the neighbours complained of the smell from his flat. There was no one else inside. No photographs, no clues. Delicate women's garments hung in the bedroom closet. But no trace of the woman who had worn them could ever be found.

Meanwhile, in Nagaland, almost halfway across the world, a young man of the Angami tribe was readying himself for a night to remember.

'Not that house, Balie, you don't know what you're letting yourself in for!' his friend protested, 'You can be my guest. I don't mind at all. I have a big house, plenty of room now that my sister's away.'

'Oh, don't spoil the fun.'

'All right, but don't say I didn't warn you. Though I can see you're not in the mood to listen.'

'You're right,' said Balie and headed out for the hotel, the big house built on the river bed.

In the middle of the night, Selhu was woken up by a loud, desperate knocking on his door.

'What? Who is it?' he asked.

'Open the door, Selhu!' Balie screamed, 'Open the door, quick, they're after me!' Selhu rushed to open the door, and a hysterical Balie fell headlong into his room.

'Good God! What's happened to you?' Selhu asked. Balie's shirt was unbuttoned, his eyes wild and unseeing.

'Hey, take it easy man, you're all right now, you're with me, okay?'

'There were two of them . . .', he gasped.

'It's okay,' said Selhu, trying to calm him, 'don't talk now, I'll get you some coffee.'

'No, no, I don't want coffee.'

'All right then.'

'I was drunk when we parted last night,' Balie began. 'I remember you asked me to come back with you but I refused. Back in the hotel, they gave

me a big room, saying that no one else was there for the night. Actually, I was too drunk to care. I think I fell into bed with my clothes on. A few hours later, I woke up. There were people in the room. I heard soft giggling and women's voices. I rubbed the sleep out of my eyes and looked to see. There were two of them, very, very beautiful young women. One, I thought I recognized as a friend from my college days. Anyway, when they saw I was awake, they came over to me, asking me to join them for a party in the next house. At first, I refused because I was too tired, but they insisted in such a way that I couldn't refuse. I got out of bed, walked to the door and, pulling it open, I grabbed the girl next to me: "OK, let's party!"

'But Selhu—there was nothing there! The girl did not have a waist where her waist should have been! That really woke me up! I said: "Wait a minute, something's wrong, why can't I hold her?" I grabbed at her arm this time, and the same thing happened—nothing but thin air. By then, my head had cleared. The two of them kept giggling at me but I just ran out of the door and came here, to you. It's some distance, isn't it? They followed me, Selhu, I heard their giggling turn into cackling, like the laughter of old women, and I couldn't get that sound out of my ears. That's why I was in such a state when I got here.'

'Hmmm, river spirits, no doubt. They've been seen in that big house before. It was a mistake to build on the river-bed. It angers the spirits, because it's taboo. River spirits are ethereally beautiful but they never let a man get a good night's sleep. I tried to warn you but you were in no state to listen.

'They're called *mammy-wota* in Nigeria, mother of the water. They are the most beautiful of spirits. They've been sighted frequently at African

markets. The old women say they come up and mingle with the market folk so unassumingly that you'd never suspect they are spirits. If you catch a glimpse of her, you want to look again because she is so beautiful. But when you look a second time, she's disappeared. The trick is to keep looking out of the corner of your eye.'

'Oh, I'm done with looking.'

'You know what you should have done?'

'What?'

'Made your heart big and caught one and asked her for a boon. They're famous for granting wealth or fame or beauty. I've heard of a man who caught one and asked for wealth. In two months, he was the richest man in the village. But they say that if you ask for a beautiful woman to marry, it displeases them because they consider themselves more desirable than any human.'

'Ahh, I've had enough of spirits for a lifetime.'

'Yes, I understand. But a river spirit is probably preferable to an earth spirit. My uncle, now—he would never go home before midnight. He was a great card player, and no amount of nagging from his wife could keep him away from his game. Well he was coming home as usual after a game when he saw a man at the village gate. He brightened up, glad for the company and quickened his pace.

' "Out late tonight, aren't we?" he greeted the other fellow. The chap did not respond but opened his red warrior cloth and gave a bloodcurdling warrior's yell. As my astonished uncle watched, he continued to ululate and ascend heavenward. My poor uncle ran back to town, back to the card-

playing house, on the way he fell into somebody's hedge and, boy, was he a mess the next morning! Bruises and scratches all over. Lost his watch too, he did. Mind you, he's never been home late after that.

'But I've got a topper of a story from my friend whose friend is Nigerian. Beneme, that was his name. It's Beneme's father's story, actually. Back in '71, Beneme's father was so sick that there was nothing the doctors could do to help. That was when his people brought in the witchdoctor. They're very much like us, the Igbos of Nigeria, they have more faith in their medicine men than in their doctors. Well, with the old man on his deathbed, barely breathing, they brought the witchdoctor home. The man mumbled something and, before Beneme's eyes, two places swelled on his father's belly, just under his skin. About the size of a child's thumb. The swellings began to run around beneath his skin and the witchdoctor gave chase. After an hour or so, the witchdoctor made an incision and firmly drove one to the hole. He never let go of his grasp but pulled the object out and smashed it on the ground.

Beneme was a little boy then and was watching every move the witch-doctor made. The smashed thing on the ground looked like a snail, he said. But there was still one more to be got out, and the witchdoctor began to chase it. Soon, he caught that too, pulled it out and then, with his free hand, smashed it on the mud floor. Then he spat on his hand and closed up the incision. "That was what was troubling him," he said, "he'll be all right now. Make him some chicken broth." And the witchdoctor collected his bag and left before the family could thank him.

Beneme's mother ran out with a red rooster and begged him to take it, not as payment but as a token of gratitude.

Back in the house, Beneme's father woke with a start, got up out of bed and asked for food as though nothing had been the matter with him for the past two months. His wife made him some chicken soup which he ate with great relish. Then he picked up his *jembe*—his hoe—and left for the field, exclaiming that he had to finish the yam sowing and shouting at his family for not letting him work!

The Man Who
Lost His Spirit

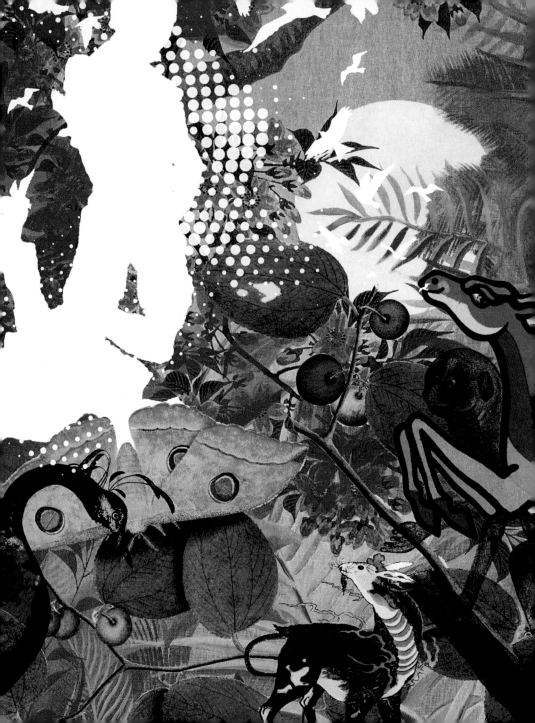

A man once climbed up a great tree in the forest. When he climbed back down, his spirit was left behind in the tree. He then fell so ill that his relatives gathered in his courtyard, waiting for him to die at any moment. The only sound in that darkened house was the slow rasp of his breathing. His wife sat by him, wetting his mouth with a damp cloth and wiping her tears away.

His clansmen heard what had happened. They knew that part of the forest. 'That is not a place you go alone,' the elders said, 'It is dangerous. Didn't he know?'

'Everyone knows,' one of the men replied, 'he must have forgotten.'

In a desperate effort to save him, his male relatives went to the seer. 'He has left his spirit behind,' the seer said, 'You must go and call it back as soon as you can. Do it at first light. Pretend you don't know the way home. Let it lead.'

The men set out for the forest as soon as it had grown a little light: three men, two of them carrying pan lids, the third a spear. When they were at the foot of the tree, the first man called out, 'Pesuohie (for that was their kinsman's name), come on, we are going home.' There was no response. The men began to beat on the lids, a terrible clanging noise. The silence in the forest magnified the clamour. In-between, they called out, 'Come on, we haven't got all day!' After some time, one of the men said, 'Come, come, your friend is ailing upon his bed!' And there was a rustling in the upper branches. The men looked at each other knowingly. The one with the spear held it close, trying not to look threatening but prepared for any eventuality.

The next sound was ever so slight: a soft footfall, barely audible. The men cocked their ears and exchanged knowing looks. 'Pesuohie,' called out the first man, 'you must lead the way, we don't know these parts well.' Then he picked up his lid and pretended to start walking. But slowly enough, so as to give the spirit time to position itself before them.

'You go first,' said each man as they herded it gently back towards the village.

Soon they came to a small stream and the first man spoke again: 'I still don't know the way from here.' The coaxing was incredible to see—over and over again, they spoke as to a recalcitrant child, humouring it when it tarried and urging it homeward. Eventually, they spied the path to the village and the first houses at the corner. 'Better hurry now,' said the second man, 'the wife will be anxious.' They soon arrived at the gate of the house. '*Ei*,' called out the first man, 'you are the host here—you must go in first.'

The man lying on the narrow bed, insensible to anything around him, began to slowly recover. He coughed, and opened his eyes for the first time in three days. 'Oh, how tired I feel. Have I been sleeping long?' His wife smiled and lifted a glass of water to his lips. 'Drink that slowly, you'll feel better.' Not daring to let him out of her sight, she called to her daughter, 'Ninuo, a cup of warm tea for your father!' Surprised, the girl came running. 'Mother! Has he woken?' The man was now struggling to sit up, aided by his wife. His relatives soon arrived, and gathered around the foot of his bed. 'Pesuohie, go easy on yourself. You have not eaten in three days; you must slowly recover your strength.' The clansmen and relatives all rejoiced at his recovery. The seer had been obeyed; the three men had gone to the tree, and succeeded in calling back Pesuohie's spirit. Had they waited one more day, they would have lost him.

But in the days and weeks that followed, the man began to change in subtle ways. He would fly into a rage over the most trivial matter. One day he even struck his wife who grew cold with fear. Who was this stranger who had usurped her husband's body? For Pesuohie had never lifted his hand against her before. Now, nothing went right as far he was concerned. The rice was not cooked properly; the firewood was damp; the things he was looking for in the inner room were not there.

His wife was dismayed at the change. 'What is wrong?' she cried. 'What has this incident in the forest done to you? You are no longer yourself!'

Her words seemed to strike him like arrows. It was only with great effort that he held himself back.

The next day he alarmed everyone with his decision.

'Go up the tree again?' shouted one of the men who had helped call his spirit back, 'Are you mad?'

'I must,' Pesuohie replied, 'I have left a part of myself up there.'

'You're mad. Well, I'm not going back to bring your spirit home again.'

'Please, don't go,' his wife begged, 'we will lose you again. You don't know how it was for us.'

But his mind was made up. With a shake of his head, he picked up his *dao* and walked out. His wife slung her six-month-old baby on her back and followed him. The baby began to howl for milk as they made their way deeper into the forest.

'Stop, Pesuohie! Come home with me. I can't follow you any further.'

'Then don't!' Pesuohie shouted and began to run. His wife ran after him but couldn't keep up, and he sprinted deeper into the trees. The woman began to weep—but it was no use. With the child on her back, she could not go on. She sat down to feed the crying child and then, after waiting for a long time, sighed and came home with a heavy heart.

Pesuohie found the tree without any difficulty. It was as though the tree wanted to be found. There were other big trees there too but this one was quite distinctive. It was old and grew very tall and then spread out at the top. Pesuohie found footholds that seemed to be waiting for him, and clambered up swiftly, his *dao* in its sheath strapped to his back.

There were things he had not told his wife and kinsmen: he had been to the seer, who had sworn him to secrecy. In a pouch slung across his chest, he carried a powder the seer had given him.

At the top of the tree, he felt his spirit slipping out of him. It was a slow, slithery movement—how strange it felt as it slid off his chest, groin and lower limbs. He steeled himself. This was the way it was supposed to be. But this time he would not be defenceless nor without knowledge. When his spirit had left him, he was overcome by a great fatigue, but his mind stayed alert and he saw other spirits come to join his own. One of them was a girl spirit and he was struck by the look in her eyes—she looked so evil. Taking his spirit by hand, she led it away and they glided upward.

He waited. If he moved too quickly, he would destroy his chances.

The seer had said that it was important—no, it was a matter of life and death—that he stay very still for fifteen minutes. It was the longest fifteen minutes of his life, but he did not move an inch. The spirits returned, and he was able to see more in his mind's eye. There were other spirits with them. He recognized two of his neighbour's children who had died within a few days of each other; their mother had been heartbroken. There was an old man's spirit too—he realized with a shock that it was his father's cousin. The spirits of the dead and the spirits of the living mingled with familiarity. There were no barriers between them.

Pesuohie's own spirit seemed to have completely forgotten him. But when it looked at him once with a look of pity and mild curiosity, Pesuohie quickly threw the powder at it. The action caught everyone by surprise, and the spirits fled in fear. Some of the powder had landed on his spirit— Pesuohie sprang to its side and poured some more. The spirit opened its mouth to scream but no sound emerged. Pesuohie drew his *dao* and quickly made cuts in the tree, marking off the place where his spirit lay. *Use metal to deflect the power of evil spirit presences,* the seer had said. The

other spirits drifted further and further away, as though they had become impotent. Finally, he finished marking the boundary around his spirit. The girl spirit stood at a distance, looking at him with deep hatred.

Then Pesuohie felt his spirit return to him. This time he watched as it climbed towards him and spread itself on top of him. 'Not yet!' Pesuohie shouted, 'not like the last time!' His spirit stopped and bowed its head. 'Is that clear?' Pesuohie asked again loudly. The spirit made a slight movement with its head, and Pesuohie stopped resisting its re-entry.

Down they went, at an unhurried pace. At the foot of the great tree, he struck the trunk with his *dao* and pronounced, 'I am Pesuohie! Sky is my father, Earth is my mother, I believe in *Kepenuopfü*! No one can harm me!'

The other spirits did not follow them home.

All the way back, Pesuohie spoke to his spirit, reminding it of the things they had experienced together. 'Is life not sweet? Do you remember the day we swam in the river? How Bunyü was swept away by the water and we could not save him, but he caught the branches of a tree and came back to land? I have never forgotten how precious life is from that moment on. And remember the hunter's bullet that whizzed towards us at the community hunt? If you had not pushed my head down! Wasn't life sweet after that? When we come so close to losing it, isn't life always so good?' He talked constantly to his spirit as they walked out of the forest, and carried on until they reached the field-path. It was dusk and Pesuohie could not see anyone around him.

At the crossroads, he felt his spirt make a sudden movement. 'No, my friend,' he admonished, 'you are coming home with me. I am the stronger

one today. Do not squirm so, if you don't want to feel the powder which is harmless to me but which brings you much grief.' His spirit stopped wriggling, but Pesuohie kept on talking until they were near the village. Some people stared at him as he walked quickly past, talking loudly all the while but to a companion who was invisible to the naked eye. The village was small and everyone knew what had happened to him the month before.

As they neared the square, Pesuohie said to his spirit, 'Let's sing that duet we sing so well together—I shall take the first voice and you take the second.' Then he burst into song, singing a familiar folk tune but pausing at places where the second voice was supposed to come in. Witnesses later swore they had heard a thin voice singing the second voice, but saw only one man.

Pesuohie's house lay beyond the village square. The situation was still dangerous. He walked on singing his lone song, beginning another whenever he finished. He was thinking of the woman whose spirit had refused to enter her husband's house and left her at the gate. It was crucial to get his spirit beyond the gate of his house—only then would he be secure. They walked on, and his singing grew more urgent. People watched from behind their doors, awed by the strange ritual. A man who had left his spirit behind in the forest would be helped by his clansmen to get his spirit back. But who had ever heard of a man trying to bring his own spirit back?

When they drew close to his house, many people saw the lean, tall man and his spirit clearly, walking side by side, heading straight for the house. Suddenly they paused—one figure was trying to flee. The singing grew louder, interspersed with high-pitched ululating. The two figures seemed locked in a deep spiritual battle. Louder and louder sang the man, and the

spirit was trapped—it was obligated to sing the second voice. Slowly, they passed through the gate. Pesuohie's wife flung the door open. The last thing the villagers saw was two figures collapsing in a heap at the entrance.

The woman pulled her husband in, and shut the door.

The Man Who
Went to Heaven

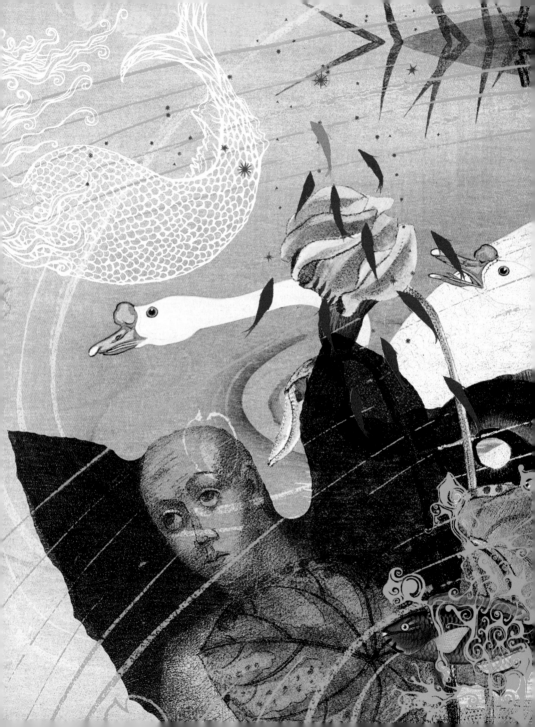

Once upon a time, a young man had a pond. Its water was so clear and sweet that it went down your throat like morning dew, and left in your mouth the lingering taste of honey. The young man was very proud of his pond. But one day, early in the morning, he discovered the water had turned muddy. This went on for a week. Someone was dirtying the water before he arrived to get some for himself.

The man decided to wake up early the next day and keep vigil by the pond. It was not yet dawn when he crept out and then lay in wait. Suddenly, to his surprise, he heard the tinkling of bells. When he looked in the direction of the sound, he saw blurry movements in the dark skies—something seemed to be floating downward. Suddenly, the skies were lit by a fine golden light. And he saw beautiful sky-women coming down to earth, singing a sky-song. There was light only where the sky-women were; the rest of the sky was still dark. The man was mesmerized. From his hiding

place, he watched them remove their smooth tails and slide into his pond, one by one, and play in the waters. 'Ah! so this is what is muddying my pond!' he thought. How beautiful was the sight, the smooth-limbed, light-skinned sky-women bathing in the pond, spraying each other with water. He could not take his eyes off them. Their shoulders gleamed in the faint light and seemed to him the most glorious sight he had ever seen. As he gazed at them, the first rays of morning flickered over the mountaintops. The sky-women grew alarmed. The oldest among them called out to her sisters, 'Quick, we must go back before our husbands wake up!'

They came out of the pond, put on their tails and, with the first sister leading the way, sang their way up to heaven again.

This went on for three mornings. On the fourth morning, the man woke up earlier than usual and went out to wait for the sky-women. While they were at play, he hooked the tail of the youngest, the prettiest of them all, and hid it. Their water-play over, the sky-women prepared to ascend to their heavenly home. But the youngest could not find her tail and grew distraught.

'We must go now,' her sister said, 'for if we are not home when our husbands wake up, they will be angry.' Then they rose up into the sky and went away, leaving the youngest behind. The sky-maiden wept and wept as her sisters slowly disappeared. The man's heart was filled with pity, and finally he revealed himself to her. Frightened, she wept some more. But he spoke so gently that she was calmed by his words and she slowly followed him home. The man treated her with tenderness and care until, many days later, she fell in love with him and willingly became his wife. They lived together as man and wife, the happy earth-man with his sky-wife, she of

the gleaming shoulders. She learnt his earth ways and cooked for him and worked in the fields beside him.

The two lived happily for many years. The sky-wife gave birth to two children, a girl-child first and then a boy-child. The sky-wife and her husband then took turns to go to the field, because the children were young and needed to be looked after. One day, the girl-child said to her mother, 'When we have been very naughty, Father takes out something and frightens us. It looks like a tail.'

'Really?' said her mother, 'Do you know where he keeps it?'

'He said we were never to tell you or show it to you,' said the boy-child.

Their mother promised to never let their father know. The children led her to its hiding place. There she found, carefully hidden beneath old wood and straw, her long-lost tail. She picked it up and held it to her. Memories of her former life in her sky-home came rushing back and she was filled with longing to return. She felt anger at her husband who had betrayed her by hiding it all these years. There was no doubt in her mind that she would return to her sky-home.

The sky-wife went out into the front yard and put on her tail. She told her children she would send down a rope to pull them up by. Then she began to sing her sky-song and ascend to her sky-home.

When their mother was gone, the two children felt very sad. Just then their father came home. When he heard what had happened, he shouted at them for telling their mother their secret.

The girl ran out of the house, crying. Her mother, who was watching from heaven, quickly sent down a rope. The girl clambered up to her

mother's sky-home on the rope. After some time, her brother ran out of the house in tears because their father was still shouting. His sky-mother dropped a skein of thread. The boy picked it up: 'Oh, what an excellent skein of thread! I shall make a top out of this.' As soon as he held the skein, he was drawn up to heaven.

The man was very lonely when he found himself alone in the house. The next morning, he went to the raven and asked for his help to get to heaven. The raven was the most intelligent of birds. It was white all over. The raven said, 'If you turn my feathers black, I will lead you to heaven.' The man readily agreed. He made a paste of charcoal powder and water and painted the raven black. This is why ravens are black to this day. The bird was very pleased: 'I will fly to a mountain and call out to you from there. You must climb up to me. I'll keep calling, and you keep climbing, until you get to the gates of heaven.'

The two began their arduous journey, the bird calling out from every tall mountain. After many long days, they reached the last mountaintop. The raven said, 'Look, there, towards the east. You can see the gates of heaven. I will leave you here. If you keep going, you will find your family.' The man thanked the raven and they parted.

In heaven, the sky-wife was busy weaving a cloth when her children began to cry out, 'Mother, it's Father! He's come!' The sky-wife stayed bent over her weaving and said, 'Oh, how could your father possibly come here? Go, wash your eyes and look again.' But the children were right and the three of them ran happily to him. By this time, the wife was so glad to be back in heaven that she had forgiven her husband, and now they all embraced and welcomed him.

They spent many joyous days together. The sky-men greeted their brother-in-law warmly. They talked about what they could do to entertain him. 'Ah, I have got it. Let's take him hunting,' one of them suggested. Out on a hunt, the man saw a shrew-mouse run towards him. The sky-men called out to him to shoot. The man shot it, but wondered what they would do with such a small animal. But the sky-men were very pleased and they bore him back home, shouting, 'Our in-law has killed a stag!'

The man thought to himself, 'Ah! so they call the shrew-mouse a stag!' That night there was a great feast and they cooked the shrew-mouse and ate together. Even though the shrew-mouse filled only a small pot, everyone ate and ate until they could eat no more.

But it worried the sky-wife that her husband was a careless man—he always let his curiosity get the better of him and wandered all over heaven, exploring it on his own. 'There are some extremely strange sights in heaven,' she warned him one day, 'You must never remark on them.' Then she told him of the beings called Tietheriü, who had pointed mouths with which they wove cloth. 'Never make the mistake of laughing at them,' she said over and over again. The man promised to be careful. And then went on his way, roaming around his new sky-home, taking in its sights and sounds.

One afternoon, through an open doorway, he saw a creature weaving. One of the dreaded Tietheriü, or 'Pointy-Mouth Ones' who wove cloth with their shuttle-like mouths. The sight struck the man as incredibly funny. Try as he would, he could not help the gurgle that ran up his throat and escaped in a loud guffaw. The creature was enraged—it got up and gave chase. The man was swift-footed and reached home much before the angry

weaver. He frantically told his wife about his great blunder. She hid him under seven grain baskets and told the creature there was no one home but her. Nevertheless, the Tietheriü sniffed her way into their house, and said, 'I can smell his presence here.' Still sniffing, she went over to the seven grain-baskets under which the man lay crouching. She gnawed her way through the baskets until she reached the man's scalp. And then she sucked his brains out.

That was the end of the first man who tried to live in heaven.

One Day

*(Based on a
Konyak Folktale)*

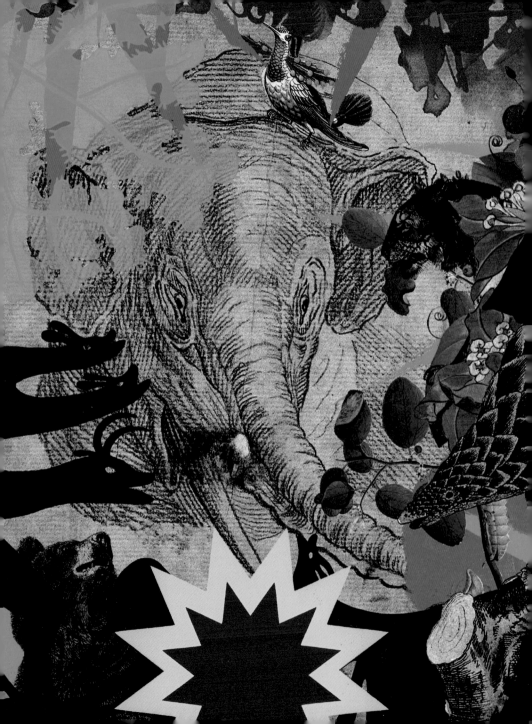

One day, when the time was right, God came down to earth. The quietness of that day was unlike any quiet that would ever be again. It was different from loneliness because you can't be lonely if you've never known the presence of a human being, a shadow of yourself, a mirror of all the feelings that, some time or another, you have known. Like a great, deep aloneness was the voiceless vastness of the land that spread out in ranges of primeval mountains or the seas of water gravitating towards the smaller ball of light in the skies, its waters ebbing and flowing ceaselessly.

'It needs to be dominionated,' God declared, and His mind flung together strong sinews and flame-thrower eyes into that brave terrible, the tiger.

Great feet pounded the earth and ivory-white tusks thrust at the air as the elephant burst into existence; and all around them the flap-flap of a

thousand and more creatures of the air; and on the seas, water animals pirouetted the lengths of the waves. The other animals were already making their homes in the greenness and beginning to procreate.

In the midst of all this, God took a small clod of clay in His big hands and breathed His breath into it and called it Man. Smaller than many of the animals, inept at swinging from trees, unskilled at flapping his arms and uninitiated in the world of waterways, this new creature called Man was mortally afraid of both the animals of land and the animals of water.

'Oh creator God, please give me more strength than them,' he begged every day. Walking alongside his latest creation, sometimes lifting him to his feet if he stumbled and fell in the undergrowth, God said, 'I can't give you more strength, because I made you last but I will give you something before I go back to heaven.'

Every day Man begged God to protect him, until, one day, he took out a long stick that was pointed at one end, and gave it to the man. 'This is a firestick. It has great power, such great power that it will destroy all those you fire at, so, use it only in times of great danger.' Then, as God got ready to go back, he told Man, 'Mind, you don't fire that stick until I have entered heaven.'

Once God was gone, the man forgot everything that God had told him. He was so happy with his firestick that he forgot all the warnings about its use. Impatient, he fired it. God was in the upper reaches of heaven when He heard the loud retort. He ran down to earth again. He found the firestick in the man's hands, with smoke curling up from its pointed end.

'Why did you fire?' God asked.

'I'm just trying it out,' Man replied. But God did not like it at all. 'The way you did it—*mmhü*, I don't like it, no I don't.' And God took it away from Man.

'I'm sorry, I won't do it again,' said Man, 'please don't take it away.'

'I'll send you another one.' said God, and turned away from Man, climbed the last tall mountain, heaved Himself up onto the clouds and went back to heaven.

Every day, the animals walked past Man. They had their young with them, and female animals heavy with child fed on the fruits fallen on the forest floor. Man worried as they watched him languidly with mildly curious eyes.

'Oh creator God, one of these days they shall surely be my death. Please keep your promise to me.' Finally, God felt sorry for him: 'My son, kill a chicken, remove the flesh and carefully examine the joints of its leg. You may fashion a firestick after it.' So Man did as God told him, and fashioned a firestick like the leg joint of the chicken.

Then Man went out with the firestick, and Man knew no fear because he knew the power possessed by the stick. He walked up to the elephant. 'Coming after me with a stick, are you?' snorted the elephant, and tried to wrap his trunk around it. Man was ready—and he fired. And the sound was heard in heaven too. Fell to earth, the elephant did, in a flurry of dust and dead leaves—and there was such amazement in his eyes before they closed in death.

The she-bear saw it all. She ran back to the other animals, and said: 'Don't have anything to do with that creature—the one who calls himself

Man. I was there when he raised this little stick and waved it at Elephant. And when Elephant was almost upon him, and I was thinking surely he would be killed, and God would have to make another thing called Man, he fired the stick at Elephant! And poor Elephant, he fell—fell to the dust and died there, you can still see his mouth hanging open from the shock of it all!'

The Man Who
Became a Bear

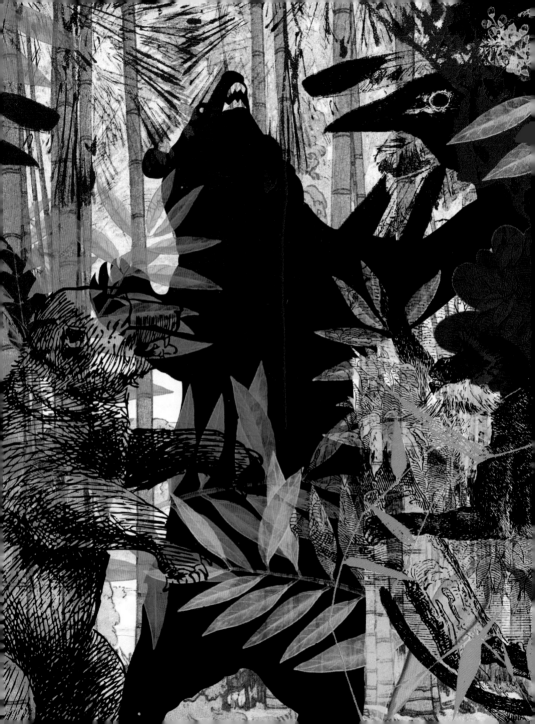

Ridiculous, they said. Go scare the children with that, they said. But what of the family who had a loved one go missing, never to be found again? And what of the man who never came back and of whom the seer said: 'He is alive but he is no more a man'?

When the cicadas were singing their going-home songs, did he not scrape the mud off his hoe and tip the ash out of his tobacco pipe and slip his machete into its holder hung on his belt, and did he not set off for home just like all the others? Who can describe the strange voices he heard in the river, sweetly calling his name? Or the stranger voices that knew him in the woods and drew him into their depths?

His clansmen led the search, combing the forest and the fields in twos, careful to turn away from the sweet sounds of the river and the soft calls from the woods, inviting the searchers to tarry awhile. A man heard his name whistled twice, and, thinking it was one among their group, tried to turn into the treacherous woods. 'No, no, are you mad?' cried his friend and pulled him back. At such times, it was necessary to be harsh—that was the only way of shaking a man out of the spell that the creatures of the wood began to cast upon him if he stopped to listen.

The search was fruitless.

'Did you not come upon even a piece of clothing?' his wife asked anxiously. But he had disappeared, left not one tell-tale sign—no bit of work cloth clinging to a thorny bush, no stub of half-smoked native tobacco on the forest floor, no knife dropped in passing as in the case of Vilhou's younger boy who was found two days later. He said he'd been playing with a little boy who had called to him from behind a twisted old tree. He was very upset when his father found him and dragged him back home.

The woman who had walked out one afternoon to gather herbs had never come back. Six months later, a hunter came upon a clump of hair and a weatherworn body cloth covering the remains of what had once been a mother.

But it was different this time. The seer had said, 'If you don't find him soon, when you do, he will no longer be a human.' They all wondered what the seer meant, but that was all he was allowed to reveal. So the whole village turned out to look for him. By the fourth day, everyone was exhausted and his relatives did not want to press them further. Reluctantly, the search was called off, but a funeral was kept in abeyance until such a time when hunters might chance upon his remains or the seer could convey he had entered the valley of the spirits.

He awoke and found himself in a dark room. He felt along the unfamiliar walls for a window but found none. Where was he? He tried to recollect but could not. A faint glimmer of light lay to his left. He half-walked, half-crawled to it, very carefully and slowly. The last time he had come home late, he had knocked two chairs over and made such an ungodly noise that his wife would not give him any peace for the rest of the week. He'd be more careful now. But if that was a window or a door up ahead, it was the wrong shape—it looked as though somebody in a great hurry had

smashed through a wall. Never mind. Here it was—the entrance to this odd house. His head felt heavy but surely he hadn't slept so long or drunk so much the night before? Where were the children? They were early risers, up at the crack of dawn to resume the play of the night before. And why were there so many trees? He had cut them all down save two to clear his front yard. Where was his wife? If the children were up, she rarely lingered in bed. Why hadn't she brought his tea? 'Wife, wife!' he called out. What's wrong with my voice? I must have a sore throat. Serves me right for staying out too long. 'Wife!'—was that growl his voice?

The sun was beginning to rise when he glanced down at his feet and recoiled in horror at the black fur that covered them. 'Oh my God, when have I grown so hairy?' He lifted his hand to his mouth and drew it back at once when he felt the furriness of it at his lip. He held out his hands, up against the light, and a long scream tore out of him at the sight—his hands were black paws, with sharp claws where his fingers should be. 'What's wrong with me? What? What?' The question shrieked in his head and his hands clawed desperately at the fur, trying to wrench off the bearskin. But the pain and the blood that began to ooze from the scratches stopped him. If only he could find somebody to help him. His wife and children were there, of course, but would they accept him now? It would have to somebody who was acquainted with metamorphoses of this nature. It was then that he thought of the seer. Ah, perhaps the old seer could help him, he knew enough magic.

The missing man felt clumsy in his bear-body. He was not familiar with the forest where he found himself, so he traced his way slowly, looking for clues and signs of human habitation. There were no fields but he could see a jungle path—an indication that a village was not too far off. He wondered if he should stay on the path or crawl along it and sneak into the forest to hide if a man should come along. Was he to act like a man or a bear?

He had not been walking more than fifteen minutes when he saw two dark figures up ahead. As they drew closer, he was dismayed to see that it was a she-bear with her cub. Expecting her to charge, he looked around for an escape route. But to his surprise, they walked past with no sign of the hostility that a she-bear would usually express on encountering a man.

The sun was up now, but there were still no men in sight. As he walked on, he found a field of maize, the ears of corn yellow and ready to be picked. He began to drool—he had not eaten for a long time. Surely, they won't miss a few ears. *And I can always pay them back when I am well again.* He settled down in the heart of the cornfield and began to eat. He was surprised at how good the corn tasted—it was sweet and sticky and the last cob whet his appetite for more.

'There he is! We've caught the rogue this time!' *Ah, people at last. I'll explain everything and then they'll help me,* he thought as he pulled himself up to his full height. At once a bullet pierced his abdomen. He reared back from the pain and roared. 'Stop! Stop!' he raised his hands and struggled to speak, but only strange bear noises came from his throat and frightened the men even more. Another bullet pierced his chest and exploded in his heart. Only then did his voice come back to him, 'Don't shoot please, don't shoot—I'm a man.'

The hunters heard his words above the din of gunfire before he fell down dead.

'Could it be the missing man?' one of them cried out and ran up to check. Pushing aside the fur, they found on his shoulder a long white scar. His relatives had been asked for identifying marks. His wife remembered the wound he had received at the end of a bayonet in the First World War, a scar spreading across his right shoulder like a silver arrow.

The
Weretigerman

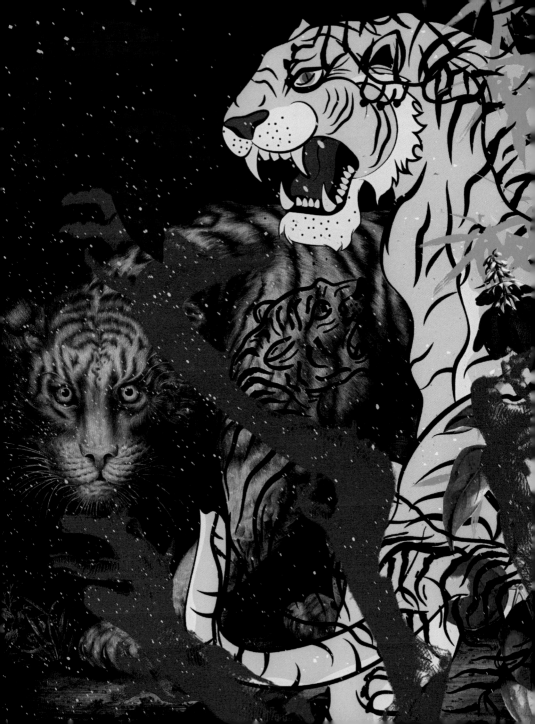

He was half-man, half-spirit, the last in a long line of weretigermen. Tsaricho's father and his father before him had carried the spirit of the tiger in them. Many in his family thought he would bequeath this strange legacy to his young son who was unformed but not much younger than Tsaricho himself when he became a tigerman. But he would have none of it. The lad attended the Mission school and sang the songs of the Lamb. It was not long before Tsaricho could tell that the boy did not have it in him to carry the spirit of the tiger. To his credit, he refrained from imposing his will on his only son. And to his elders he simply said: 'Let it be—his is a destiny different from ours.'

Was he seven or eight when his father had called him to his side of the fire and shared portions of chicken liver and fragments of country ginger with him? He could not remember now, but he could remember a time when he had not carried the spirit of the tiger. His life consisted of two parts—the first he always remembered as light and unburdened by the

knowledge that marred the other part, the part after he crossed an invisible boundary and began to walk in the footprints of his father and his father before him. If his son had showed any inclination of wanting to carry the tiger, Tsaricho would have been the last man to stop him. But the boy clung to his mother and cringed in fear on the nights when the tiger came to their compound, treading heavily on the soft soil and making low noises. Some nights the tiger came so close to the house that they could smell him—a thick, pungent smell that lingered in the spots where he had rested. But the boy's heart did not leap within him as Tsaricho's did on those mornings when he came upon the pug marks of the animal or inhaled the musk of him in the spots where the long grass was well pressed down.

Such mornings reminded him of his great-grandfather, a tall, lean man who had died when Tsaricho was five and a half. The village people called Tsaricho 'the lucky one' because he had seen his great-grandfather, the most powerful tigerman for many villages around. Two men from a neighbouring village had once made the mistake of crossing him. It had been a heated argument, and one of them had threatened as he walked away: 'See that your tiger doesn't come near our village gate. I have yet to see a tiger that is immune to bullets.' The men turned to go but not before glimpsing the unspoken anger on the old man's face. It was this memory of his great-grandfather that returned to Tsaricho—the sight of his countenance darkening like a rapidly gathering storm in the sky.

The two men never got back home. They were walking along the narrow path that cut through the woods when they heard the rumble of thunder, and all around them the trees came crashing down, uprooted and upclawed. The first man opened his mouth to shout but words failed to

come—his eyes were fixed on the giant tiger that leaped out of the darkness. His last thought was that he had never seen a more magnificent animal, the symmetry of blood and sinew wonderfully displayed in that mid-air leap.

The second man turned and ran back the way they had come. But the fallen trees raised their branches to block his exit—he ran into openings only to be pushed back by their roots and the blackening spirits of dead trees that deceived him into thinking that there were trees where none stood. The forest exploded with unbearable sounds—the wailing of old women and then the rapid yodelling of warriors. Until finally there was only the low growl of the tiger. The man could not see the tiger anywhere, though, and dared not move a step. His heart pounding, he waited for the beast to end the terrible suspense. He did not have to wait long. Claws of iron tore into him and his last experience of life was the agony of a limb torn off and that all-consuming pain compounded by another limb torn off until he could feel no more . . .

Two days later, their clansmen came out to kill the tiger and avenge the deaths of their kin. From the day the tiger was killed, Tsaricho's great-grandfather began to die too. It was not an uncommon event, for the village community had tigermen before him. But the nexus between tiger and man was still attended by the mystery and the awe that shrouds the supernatural. The old man refused to eat, saying he found no pleasure in food now. By the fifth day, he was alarmingly weak. A week after, he died. Tsaricho kept to himself what he had seen as his great-grandfather was dying: across the wall of the old man's room, the shadow of a great tiger appeared and stayed for a few seconds before life ebbed out of the man.

Tsaricho never told anyone about it because he was a child then, would anyone have believed him?

One night he began to talk in his sleep. His mother prodded him awake and, still groggy, he burst out, 'Mother, did you see it too? The shadow of the tiger in Great-Grandfather's room?' His mother shushed him. 'Hush, son, hush, you mustn't speak of these things.'

Tsaricho's career as a tigerman did not begin as soon as he had eaten from his father's plate. The next month, while father and son were out hunting, a wildcat scurried into the undergrowth. Tsaricho raised his catapult but his father knocked it out of his hands. 'Father!' he protested. But his father's grim face silenced him.

'Don't be stupid son, that cat is you!'

'Father, how can that be? Am I not a tigerman?'

'Certainly, son, but are you not a child still?'

Thus, he came to learn that a tigerman progressed from lower forms of life until he attained the final stature of the tiger.

Now that he was a grown man, his tiger was both praised and feared, a great cat almost as big as his great-grandfather's. In the seasons when the cows were let loose, neighbouring villages complained about their steady loss of cattle. What was he to do? Plagues and famines were far and few between and the village population had grown unchecked, so there was little game left for his tiger.

'I'll think of something,' his uncle told him when he confided his fears.

'There is a man who has been on his own for seven months now. He carries wounds from an ambush. Send your tiger to keep the man company

until he grows strong.' So Tsaricho sent his tiger to the banks of the river where the man was. Here, game was plentiful and the tiger was no longer hungry, and the man was no longer lonely.

When the man first heard the sounds of the tiger, he had been afraid. 'Elder brother, do me no harm,' he shouted across. But as the days passed, the man was comforted by the evidence that there was game enough to feed the two of them, and every night he called out into the darkness: 'It is I, elder brother, may you sleep well.'

The tiger heard him and stayed on, lending his presence to the man. He longed to draw closer but he knew that the man would retreat. One night, while the man was fast asleep in his tree house, the tiger noiselessly entered the narrow interior of the shelter. Smoked meat hung above the hearth but the tiger had no need of that. His great heart was filled with compassion for the man, outcast by his fellow men. With no dark thought but an overwhelming rush of brotherly love for the friendless stranger, he drew near to the sleeping form. But the man was troubled by a dream of a large tiger chasing him. With a muffled scream he awoke, and the sound so startled the tiger he turned and sped out of the tree house and made for the dark safety of the trees.

In later years, Tsaricho's son, burying him next to his father and his father's father, pondered on the desire that led men to become weretigermen. It was the power of course, but something more than that. He had himself never felt the fire to become one with the tiger. Only a few men were destined to carry its spirit, and his father had been one of them. Could it be, he wondered, that there was some truth in the story that Man, Spirit and Tiger were once brothers?

EASTERINE KIRE

The young man threw some more soil over the mound. No cross for this grave. Unhallowed ground, it would always be feared by all who were forced to cross it by night. His answers were buried in that unblest soil with the last of the tigermen and, even then, he doubted that his father had ever known all the answers.

The Silver
Dẓüli

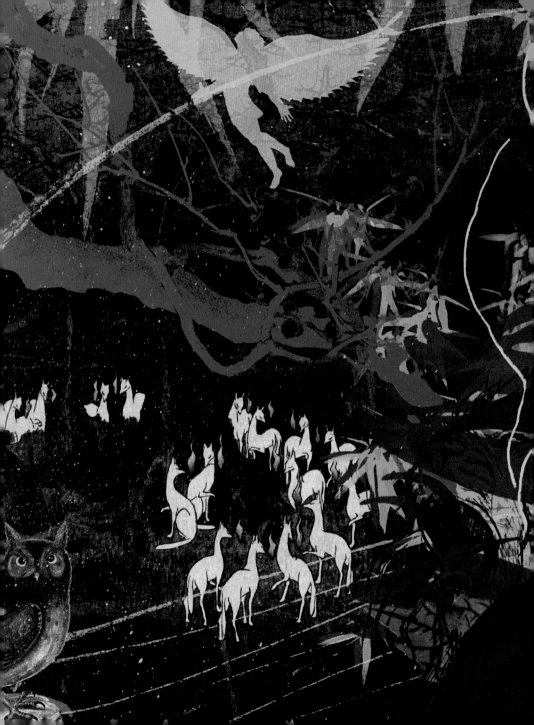

On a clear winter evening, when the clouds hold no rain, you can see the spirits of the warriors chasing each other across the dark skies. On such evenings, Thesuohie would patiently sit outside and wait for the spirit of his father.

Tonight, he was earlier than other nights. His young face solemn, he watched as one warrior shot past and sank into the southern sky. He knew it was not his father. He knew his father would not move so fast because his father knew he was waiting and watching. He saw another climbing up from the east. It climbed slowly, gaining momentum, and then shot right over his village before the bright light died in the west. That was him! That was his father—he knew, he just knew. He felt his whole body dissolving into nothingness, becoming part of the exhilarating experience of oneness with the illimitable sky and the immortal warrior-spirits. Tears streamed down his face, tears of joy. Now he could sleep and dream of the brave ones and follow them by night into regions where he could not go by day.

Thesuohie was eleven the first time the spirit of his father held him. He ran to his grandfather and recounted his experience. He was not sitting, but walking up and down, impatient for the spirits to appear. A very bright spirit shot past and he felt as though he were being caught up into the very heart of the sky. His body was no longer his—he was being hurled into the air, but all the time his father held him firmly and he lost all fear. Once they were so close to a star he thought they would surely be burnt to ash and fall to earth in a million black flakes. But he was swerved away, blinded, deafened and left devoid of any sensation. When he regained consciousness, he was lying in his grandfather's narrow yard, something wet and cold rubbing against his forehead. He opened his eyes and found himself looking up into the face of his puppy, Ketei.

Thesuohie's father had been the favourite of the village chief. The old people, gathering round their hearths, still talk of how his spirit came home to die. A young man of Thesuohie's village had travelled to a neighbouring village and drunk *zu*, the traditional rice brew, offered by his host. That night he felt a thousand rats gnawing at his stomach. So, he rose before the first cockcrow and made his way home. Stumbling in at the gates of the village, he fell as another spasm shook his body and contorted his face with pain. Convulsed with agony, he vomited once, twice, and then lay still. The villagers were woken up by the shrill barking of the dogs. They found him lying there in the early morning, the grimace on his face a silent witness to his suffering.

In the evening, the elders called a meeting of the warriors. Ten warriors were chosen to represent the village on a diplomatic mission. Thesuohie's father was the first. They found the offending household as well as the whole village on the defensive. They refused to pay the usual compensation

for directly or indirectly causing the death of a sojourner. Insult was added to injury when the offending village struck the first blow. But the ten left as many as thirty dead and nineteen wounded before they were mowed down. The next morning, Thesuohie's village gates were found adorned with tufts of hair, bloodied shields and broken spearheads. The hair had been cut off from the warrior's *tsiikhru*, the pigtail on a male child's head.

The night before the massacre, a man of Thesuohie's village heard a warrior-cry echoed by a choir of eerie voices. Some said that the spirits had danced around the village, wailing and howling like wolves. An old woman went to the water spot before the morning light spread. She saw Thesuohie's father walking away, his face turned away from her. He did not reply when she spoke to him. They found his body a few yards from the village gate. His hands still clutched the grass. A thin line of blood traced the path he had taken in the night. The Chief tore off his head-dress and cried: 'Ah my son, my son, it was you who robbed me of my sleep last night, your spirit that chased the moon behind the rain clouds, your warrior soul rising from the smoke of the village fires. Had I known, I would have, with my own spear, checked your hasty feet . . .'

Every year, Thesuohie watched the young men of his village pit their courage against the spirits to vie for the place of the bravest warrior. When the new moon was at its highest, its rounded face swollen in the fullness of its short span, they would go out in twos and search the jungles for the *dzüli*, the slender, reed-like bamboo that frequently forested the Naga hills. They returned swiftly, silently, like the spirits of the wind, making their presence known only by a faint ripple on the face of the pond. In the day, they burnt a fire and threw their challenges to the spirits. Walking round the fire, they chanted, 'Spirits of the dead warriors, spirits of they who died

in the rockslide, spirits of they who died at childbirth, spirit of him whose head was never claimed, awake, awake and see tonight if your feet are as nimble as mine.' Sometimes the two men would proudly bring back a long *dzüli*. Sometimes only one returned, and his *dzüli* would be short, his face distracted and terrible to see. But they, being under oath, never disclosed the events of the night.

In his seventeenth summer, Thesuohie stood a head taller than his grandfather. He was the tallest among the young men of his age group. His movements had a smooth animal grace about them. The village women marvelled at the tight muscles on him as he moved with the agility of a young leopard or a jungle cat. The older women said it was like seeing his father in his younger days. His face was cut on strong, handsome lines and his skin glowed golden in a crowd. He was not aware how striking he looked in the summer sun—a young, half-naked, warrior god.

The elders did not take long to perceive something different about him. Luo-o, his grandfather's friend, remarked: 'He was born under a different star, the warrior star: he will not be content with mere goodness. He reaches out to honour, can you not see it on his forehead?' Indeed, his grandfather had observed that the boy was often restless, his amazing energy unsatiated by the hunts his companions loved so well. His body, so it seemed, contained with difficulty, his straining spirit.

Thesuohie could not remember exactly when it was that he made up his mind. It had been there all the time: the knowledge that there was something more beyond the village world. Ever since his father's spirit had held him, he had known that he belonged to that other world. He wanted nothing more than to be whirled into the skies and enter into that oneness that spirit and air and spirit and spirit share.

It was a moonless night. The little fires in the huts had died out one by one. Slowly the sounds dropped lower and lower till, finally, the whole village was deep in sleep. Thesuohie crept out of the hut, and, taking care not to wake the dogs, easily sprinted the village gates. The woods were close by. Carrying only a bamboo torch, he made his way through the jungle. In the glow of the torch, the shadows of the trees danced up and down, and the breeze blew on the flame. His feet were accustomed to the stubble. He kicked away the bits of twig that fell in his way. He knew this part of the forest well; it was the same spot where he had marked a young but tall *dzüli* partially hidden by creepers. In the flickering light of the torch, he groped for the lower, hair-covered trunk of the bamboo. It only needed a clean stroke of the machete. The wind blowing through the bamboos made a whistling sound. This was the season of the 'whistling bamboo'. Very soon the rains would follow—first, the short showers that left the earth smelling fresh, and then the real rains that made the village muddy and the water-spots murky.

The ritual fire was always burnt in the heart of the forest. It was a small clearing just wide enough to allow four men to stand shoulder to shoulder. There was a time when the embers of the last fire had barely grown cold before another was begun. That year, the elders could not decide whom to give the title to. All seven pairs had returned with *dzüli* of the same height. Now the earth was cold and charred by the many years of burning the ritual fire. No grass grew here. The first Nagas who came upon it had found the footprints of the *miawenuo*. Each footprint was about the size of a seven-year-old child's foot, the sole conspicuously turned inward.

Thesuohie laid his torch on the ground and piled dead twigs and branches on it. The dry wood burnt easily, the flames crackling as they rose

higher. Spearing the ground, he made the blood-curdling war cry, 'Olu-lu-lu-lu-uuu!' The cry echoed round the forest and dwindled to an indistinguishable 'uuu'. He threw his challenge to the spirits: 'I am Thesuohie, son of the man who stole thunder from the eastern sky. Hear me, all you spirits, and tremble at my name for I am the warrior that shall pass over death— the name before which Fear runs and hides his face because he has failed to move it. I have wrestled with the best men and laid them down. I have been held by my father's spirit and have wrestled with the wind. Mark me well, I am the warrior whom Earth bore in her womb for nine years. The sun turned dark, lightning rent the skies and Earth quaked in labour as she brought forth he at whose footfall the spirits would flee. Great spirit, father of us all, look down on the events of this night and lend wings to my feet. Ulu-lu-lu-lu-uuu!'

After the echoes died down, there was a deathly stillness in the jungle air. The challenge had been made, the ancient race opened between man and spirit. The flames licked at the air, crackling and cackling like old, old women. Thesuohie picked up his *dzüli* and walked out of the clearing. The warning of the elders came back to him: *No matter how great the temptation, don't look back, death runs behind you.* Already he could hear the patter of feet behind him. He ran on, aware that he would need to be swift because he was alone. The other warriors always ran in pairs; while one held the bamboo, the other would lop off the end from the bamboo at intervals. Then it happened. His *dzüli* was suddenly pulled from behind and he was surprised at the weight that held it back. Continuing to run, he slid his machete down the bamboo and sliced off a tenth of an inch. Immediately, the bamboo felt lighter and he ran on unimpeded.

It was at the next curve that he felt the weight again. 'Take care, my brothers, or your fingers will feel the keenness of my machete,' he said as he lopped off the end. His spittle rose in his throat but he forced it down. His breath came faster. For the third time, he sliced off the end. He had reached the bamboo grove. It was not too far from the village. Behind him, the sound of running feet drew closer. His muscles hurt, his throat was parched and his heart felt as though it would burst any moment. He felt the weight on his *dzüli* as it was pulled back by spirit forces. Once more his machete slid down its slippery trunk.

Oh where was the village? The spirits were so close now he could feel them breathing down his neck—their panting breaths coming and going, hot and cold, cold and hot. He lashed at his *dzüli* and ran on again. The drumming in his ears competed with the howling of the spirits. The pack of wolves was closing in, turning the hunter into the hunted. Howl, howl, howl, they were ripping his heart out. Howl, howl, howl, they were reaching into him, drawing out his soul.

He felt all strength leaving his body. One last effort, he thought, just one and he would see the village again. Where was the village? Why was it so long in coming into view? The pounding grew incessant. 'Father, don't fail me now . . . spirit of my father . . . give me, give me strength,' he panted, his breath coming in bursts. There was a rasping noise in his throat. Ah Thesuohie, you have aged in a night, he thought.

The outline of his village loomed into his path, its gates shut fast. Very soon, the ghastly race would end. But they would not let him go so easily. His eyes watered, he tasted his blood in his mouth, welling up in his throat and flowing out through his nostrils. 'No!' he tried to shout at the pounding